A Kid's Guide to Drawing America™

How to Draw
Wisconsin's
Sights and Symbols

Stephanie True Peters

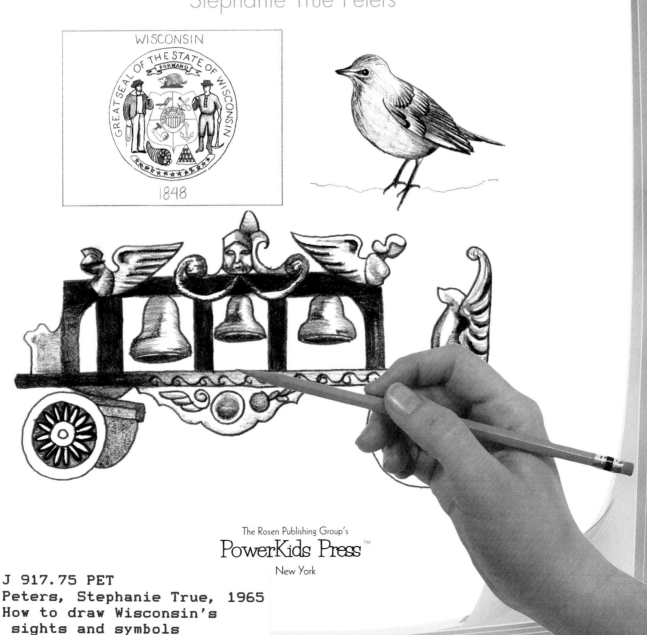

The Rosen Publishing Group's
PowerKids Press™
New York

Published in 2002 by The Rosen Publishing Group, Inc.
29 East 21st Street, New York, NY 10010

First Edition

Editor: Jannell Khu
Book Design: Kim Sonsky
Layout Design: Mike Donnellan

Illustration Credits: Emily Muschinske
Photo Credits: pp. 7, 28 © Richard Hamilton Smith/CORBIS; p. 8 (photo) © West Bend Art Museum Collection, (sketch) © West Bend Art Museum Collection, gift of Diane Plorde; p. 9 © West Bend Art Museum Collection, gift of Joan M. Pick; pp. 12, 14 © One Mile Up, Incorporated; p. 16 © Patrick Johns/CORBIS; p. 18 © W. Perry Conway/CORBIS; p. 20 © Robert Estall/CORBIS; p. 22 © James Marshall/CORBIS; p. 24 © Uwe Walz/CORBIS; p. 26 © Cy White.

Peters, Stephanie True, 1965–
How to draw Wisconsin's sights and symbols /Stephanie True Peters.
p. cm. — (A kid's guide to drawing America)
Includes index.
Summary: This book explains how to draw some of Wisconsin's sights and symbols, including the state seal, the official flower, and an old-fashioned circus wagon from the Circus World Museum in Baraboo.
ISBN 0-8239-6106-0
1. Emblems, State—Wisconsin—Juvenile literature 2. Wisconsin—In art—Juvenile literature 3. Drawing—Technique—Juvenile literature [1. Emblems, State—Wisconsin 2. Wisconsin 3. Drawing —Technique] I. Title II. Series
743'.8'99775—dc21

Manufactured in the United States of America

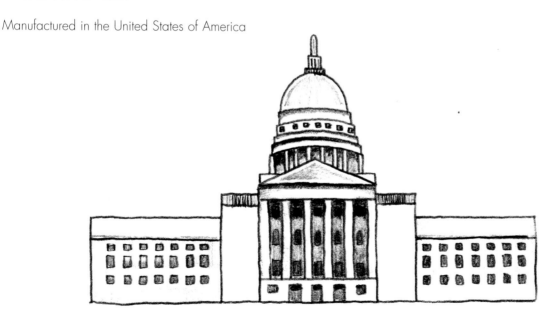

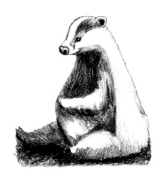

CONTENTS

Let's Draw Wisconsin

Fans of Wisconsin's national football team, the Green Bay Packers, are known as cheeseheads. They got this name because of the funny cheese-shaped foam hats they wear to football games. When fans wear these hats, they're showing pride for their state as well as for their team. Wisconsin makes more cheese than does any other state. It's also a top producer of milk and butter. No wonder Wisconsin is known as America's dairyland!

Agriculture is an important industry in Wisconsin. No other state produces more snap beans, beets, peas, and cranberries. Ginseng is a specialty crop that grows well in Wisconsin's soil. The root of the ginseng plant is used in herbal supplements and as medicine. One pound (.5 kg) of the root can sell for as much as $50! No place in the United States grows more ginseng than does Wisconsin.

The lumber industry is strong in the North Woods region of Wisconsin. Paper, paper products, and pulp are manufactured in enormous plants in Green Bay and Appleton, Wisconsin. In Wisconsin's major cities, such

as Milwaukee, there are huge plants that manufacture heavy machinery, cars, tractors, and engines. Harley-Davidson motorcycles were created in Wisconsin and are still made there today.

This book will show you how to draw some of Wisconsin's interesting sights and symbols. Follow the step-by-step directions for each drawing. The shapes you'll draw are simple. New steps are shown in red. The list below shows some of the supplies you will need to start drawing:

- A sketch pad
- An eraser
- A number 2 pencil
- A pencil sharpener

These are some of the shapes and drawing terms you need to know to draw Wisconsin's sights and symbols:

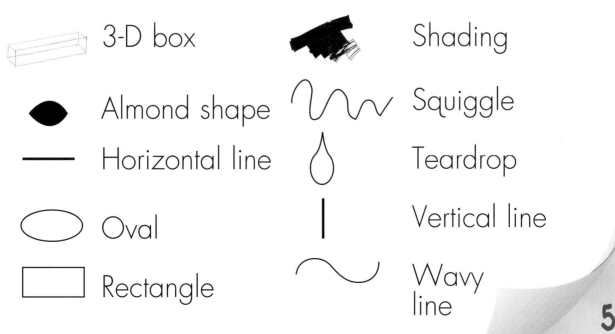

3-D box

Shading

Almond shape

Squiggle

Horizontal line

Teardrop

Oval

Vertical line

Rectangle

Wavy line

The Badger State

Wisconsin's official nickname is the Badger State. Badgers live underground in burrows. Badgers live all over Wisconsin, but that's not why the state got its nickname. In the early 1800s, miners from around the nation moved to Wisconsin to mine lead. Many of these miners didn't waste time building houses. They made their homes in the ground that they were digging, just like badgers! These miners were called badgers. Soon anyone who lived in Wisconsin was called a badger.

Wisconsin has more than 26,767 miles (43,077 km) of streams and rivers and more than 8,500 lakes. There are several places in and around Lake Superior and Lake Michigan that attract tourists to Wisconsin. People can catch a ferry from Bayfield to the Apostle Islands National Lakeshore of Lake Superior. These islands have the largest number of lighthouses of any national park. They are home to bald eagles and black bears. Tourists can also visit Door County. Door County is a peninsula that juts out into Lake Michigan.

Door County, Wisconsin, is a popular place to visit. It is located along the shore of Lake Michigan. In the spring, Door County is filled with thousands of acres (ha) of blooming cherry trees and daffodils.

7

Wisconsin Artist

Carl von Marr was born in Milwaukee, Wisconsin, in 1858. After he graduated from a German-English academy in Milwaukee, he entered his father's engraving business. When von Marr was 17, he went to study art at the Royal Academy of Art in Weimar, Germany. In 1893, he became a professor at the Munich Academy. The prince of Bavaria made von Marr a knight in 1909. In 1919, he became the Munich Academy's director.

Carl von Marr

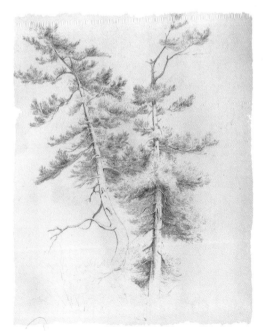

This untitled sketch of trees was done with graphite on paper.

Although von Marr lived in Germany most of his adult life, he considered himself an American citizen and once said, "I had always considered myself to be an American and did not wish it to be any other way." In 1924, von Marr was made an honorary member of the

American Association of Art and Literature. In 1929, the University of Wisconsin awarded von Marr an honorary doctorate. This award meant a great deal to von Marr, because it came from his home state where he still had many personal ties.

Take a look at von Marr's landscape below. The first thing you may notice is the dairy maid and her herd of cows. Upon closer inspection, you can see that von Marr is a master at painting light. The sunlight differs in brightness depending on where it hits the small Wisconsin forest clearing. Also notice the way he used sunlight to bring out nature's rich colors. It is von Marr's use of sunlight that gives the painting a sense of warmth and peaceful stillness.

Carl von Marr painted *Awakening of Spring* in 1884. It was done in oil on wood and measures 27 ½" x 39" (70 cm x 99 cm).

Map of Wisconsin

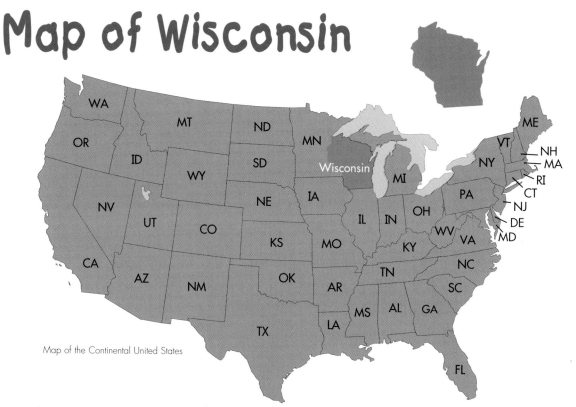

Map of the Continental United States

Wisconsin can be divided into five regions. The Northern Highland region is covered with thick forests and dotted with lakes and streams. This area is home to wildlife, such as elk and wolves. The Lake Superior Lowland is a plain that slopes from Lake Superior south to the Central Plain. The Central Plain curves across the central part of the state and contains the wetlands. Cranberries are grown there. In Wisconsin's southeast corner are the Eastern Ridges and the Lowlands. This is where Wisconsin's largest city, Milwaukee, and the state's capital, Madison, are located. Lake Michigan gives way to rolling plains in this part of the state. The Western Upland makes up the southwest corner of the state.

1

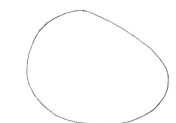

Draw an egg shape. It is wider on the left side. This is a basic guide shape that will help you draw the top half of Wisconsin.

2

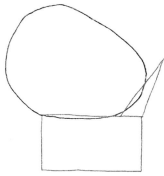

Draw a rectangle. This is the basic guide shape that will help you draw the lower half of the state. On the top right side of the rectangle, draw a long triangle. This is a peninsula that sticks out into Lake Michigan.

3

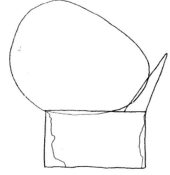

Inside the rectangle, draw the outline of the state's borders.

4

Continue to draw Wisconsin's border, including the peninsula. Nice work.

5

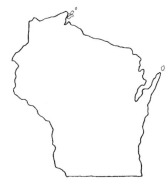

After you erase the guide shapes, your drawing should look like the one above. Add the small islands.

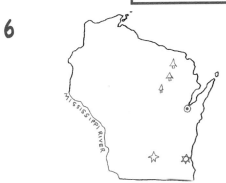

⊙	Green Bay
☆	Madison
✶	Milwaukee
🌲	Nicolet National Forest
∿	Mississippi River

6

Let's add some of Wisconsin's key places:

a. Draw a dot within a circle for Green Bay.

b. For the state's capital, Madison, draw a five-pointed star.

c. Draw a circle with six small triangle points for Milwaukee.

d. Draw three tree shapes for Nicolet National Forest.

e. Add a wavy line for the Mississippi River. You can also draw the map key if you'd like.

The State Seal

Wisconsin's state seal was created in 1881. A sailor and a miner hold a shield that shows Wisconsin's economic strengths, both on land and at sea. A plow stands for agriculture. The arm holding a hammer represents manufacturing. A pick and a shovel stand for the mining industry. The anchor stands for the shipping industry. In the shield's center is the U.S. coat of arms. Above it is a ribbon with the Latin words *e pluribus unum*, which mean, "one out of many." This is a reminder of Wisconsin's loyalty to the Union during the Civil War. Above the shield is a badger, the state animal. Above the badger is a banner with Wisconsin's motto, Forward. Below the shield are a horn of plenty and a pile of lead. These represent farm products and mining.

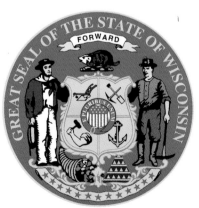

1

You'll draw the central part of a seal, which shows the shield and badger. Begin with a *U* shape. Next draw a horizontal line to close the top of the *U* shape.

2

Shape the top of the shield with lines, like the ones shown above. Add the tiny, pointed shape on the bottom of the *U* shape.

3

Erase extra lines. Draw two circles, one inside the other, in the center of the shield. Draw four straight lines from the circle to the edge of the shield.

4

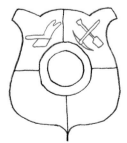

In the upper left corner, draw the plow. In the upper right section, draw a pickax and a shovel.

5

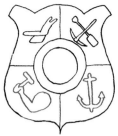

In the bottom section of the shield, draw an anchor and an arm holding a hammer.

6

Inside the smaller circle, draw stripes and stars. Draw dots for stars if the area is too small. In the outer circle, draw a pointy *V* and an *O*. These shapes make up the belt buckle and the loop. Write "E PLURIBUS UNUM."

7

Draw the badger and the ground on which he stands. Notice his tail and his pointy snout.

8

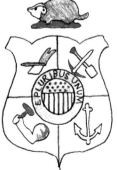

Shade your drawing.

13

The State Flag

Wisconsin's state flag features the state seal on a field of navy blue. In 1979, "Wisconsin" was added above the shield and 1848, the year Wisconsin became a state, was added below. In 2001, a group of 400 flag experts named Wisconsin's flag one of the worst U.S. flags! These experts said the flag was too similar to many other state flags. Citizens of Wisconsin were outraged. Many wrote to their local newspapers to defend Wisconsin's state flag. They said the flag represented Wisconsin's history. New designs were shown in the newspapers. People wrote to say the designs were boring or didn't show enough symbols important to Wisconsin. The debate about Wisconsin's state flag still continues.

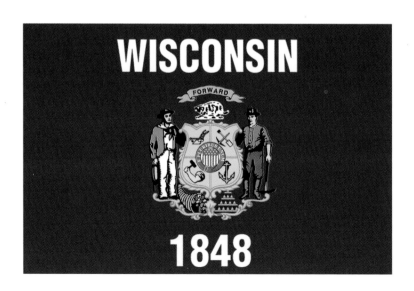

1

This chapter will show you how to draw the images outside the shield. Draw a circle around the shape of the shield and the badger.

2

Now draw the upper part of the man on the right. Draw his hat, oval head, chest, and arms. Notice how his left arm hangs down and his right arm holds the shield.

3

Now add his lower body. He wears knee-length pants and boots. In his left hand is a pickax. Next draw the upper half of the man on the left. Draw his hat, oval head, and jacket. Draw the details of his jacket.

4

Add the man's legs. In his right hand, he holds a lasso.

5

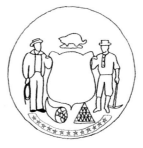

Draw a cone-shaped horn filled with small circles. Draw a triangle filled with smaller triangles.

6

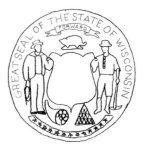

Add the banner at the bottom and decorate it with stars.

7

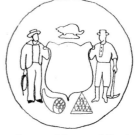

Print the words "GREAT SEAL OF THE STATE OF WISCONSIN." Then add a small banner above the badger. Print "FORWARD" inside the banner.

8

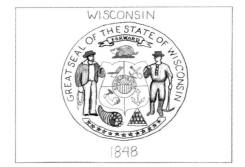

Draw a large rectangle around the entire circle. Print "WISCONSIN" and the date 1848. Shade your drawing. To draw the images inside the seal, refer to page 13.

The Wood Violet

On Arbor Day, 1908, Wisconsin students were asked to nominate flowers that could become Wisconsin's state flower. The wood violet, the white water lily, the arbutus, and the wild rose received the most nominations. On the same day the following year, the students voted for the wood violet to be Wisconsin's state flower. It would be 40 more years before Wisconsin officially adopted the flower. In 1948, Wisconsin celebrated its one hundredth birthday. During the planning of this celebration, the Youth Committee for the Centennial Commission found out that the wood violet had never officially been adopted. On June 4, 1949, the wood violet was finally adopted as Wisconsin's state flower.

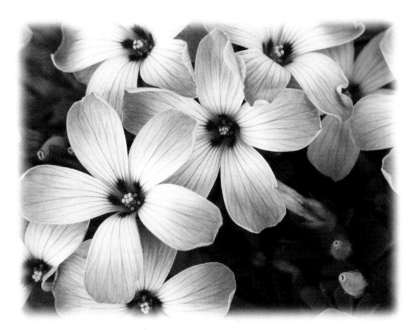

1

Begin with a circle. This will be your guide to help you draw the wood violet.

2

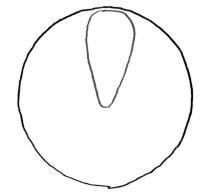

Draw the first petal. Notice how the shape looks like an upside-down teardrop.

3

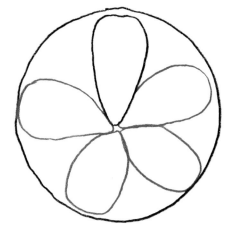

Draw four more petals. Notice that the petals don't go outside the circle you drew in step one. Don't worry if the rest of your petals don't look exactly the same.

4

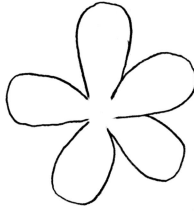

Erase the guide circle. Now erase the center area of the petals.

5

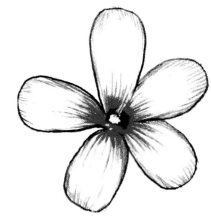

Shade the wood violet. Shade the center area darkly. Notice the light vertical stripes on each petal.

The Robin

The schoolchildren of Wisconsin voted for the robin as their state bird in 1926–1927. The robin wasn't officially adopted until June 4, 1949. That year a bill was passed to adopt the robin officially. The sugar maple and the wood violet also were adopted as Wisconsin's state symbols. Robins are easy to recognize because of their bright red breasts. In the United States, they are found throughout the nation. Robins usually migrate south for the winter, though some stay in northern states and feed on winterberries. It often has been said that robins can find one of their favorite foods, earthworms, by listening for them. This never has been proved. It's more likely that they find earthworms and other foods by looking for them!

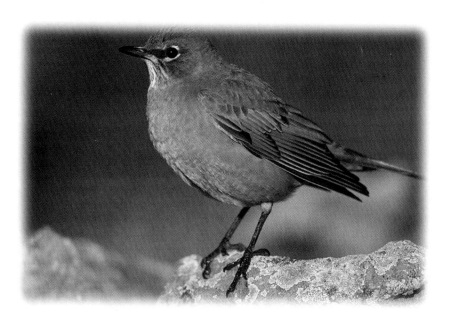

1

Begin by drawing the basic shapes of the bird. Draw an oval for the body and a circle for the head.

2

Draw the bird's pointed beak. Add the basic shape of the wing.

3

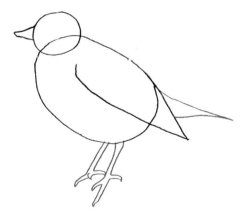

Draw the sharp cone shape of the tail feathers. Draw the bird's two legs and its long, pointy talons, or toes.

4

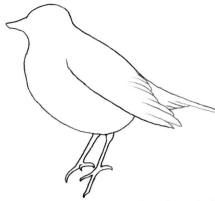

Erase extra lines. Next add detail and shape the bird's feathers.

5

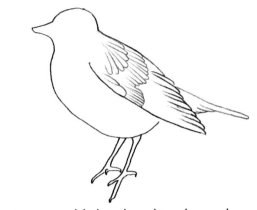

Continue to add detail and to shape the feathers.

6

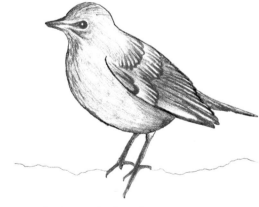

Draw a dark circle for the eye. Leave a small, white dot in the middle of the eye. Shade the bird. Notice that the bird's belly is lightly shaded.

The Sugar Maple

Wisconsin adopted the sugar maple as its state tree on June 4, 1949. Sugar maples are useful trees. The sap they produce is used to make syrup. Their wood can be made into furniture. However, it's the leaves that come to most people's minds when they think of sugar maples. In the fall, sugar maple leaves turn from green to bright red, orange, and yellow. The change happens because the leaves can't make chlorophyll during the shorter days of fall. Chlorophyll is a substance that makes leaves green. As the chlorophyll disappears, other chemicals make the leaves red, yellow, and orange. When the days grow colder, other chemical changes weaken the bond between the tree branches and the leaves. The leaves fall off the tree, to leave behind a spot for new leaves to grow the next spring.

1

Begin by drawing the trunk. The trunk splits into three large branches.

2

Add four branches that come out of the center branch. The sugar maple now has seven big branches.

3

Add thin branches that grow from the seven main branches.

4

Draw the fluffy outline of the leafy part of the tree.

5

Shade the trunk and the branches.

6

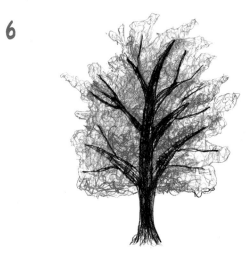

Lightly shade in the leafy part of the tree. Draw dark squiggly lines to show detail. You're done!

The Dairy Cow

The dairy cow became Wisconsin's domesticated state animal in 1971. It is a fitting choice for a state called America's dairyland! Dairy farms are a vital part of Wisconsin's economy and history. In the mid-1880s, many farmers stopped growing wheat to raise cattle. Wheat was a difficult crop and only could be grown in certain parts of the state. Cows, on the other hand, could be raised just about any place there was grass to eat. The average dairy cow produces about 90 glasses, or 9 gallons (34 l), of milk a day. To make that much milk, a cow needs to drink 18 gallons (68 l) of water a day. We can thank dairy cows for butter, cheese on pizza, and cream in ice cream!

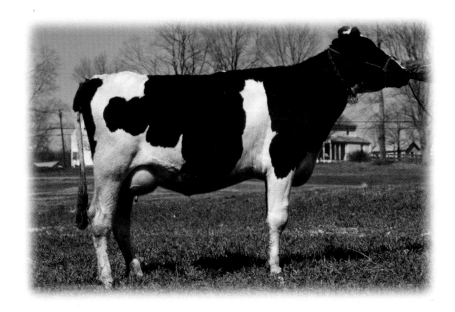

1

Begin with a rectangle. This will be the guide as you draw the cow's body.

2

Draw a triangle for the cow's head. Connect the head to the body with a line.

3

Look at the curves of the cow's hind legs, belly, and back. Use the rectangle you drew in step 1 as a guide to draw the lines shown above. The area that hangs downward is called an udder. This is where the milk is.

4

Now draw the outline of the cow's front legs and chest.

5

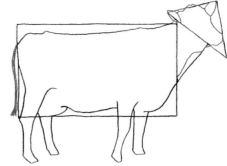

Before you draw the cow's neck and head, look at the photograph on the opposite page. Now draw the curve of the cow's neck. Use the triangle guide to shape the head. Draw the ears. Add the tail.

6

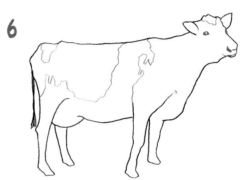

Erase extra lines. Draw the marks on the cow's fur. It doesn't have to look perfect, so have fun. Add the eyes, the nose, and the mouth.

7

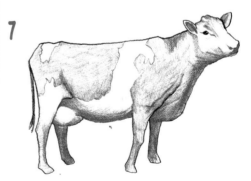

Finish by shading. By repeating soft lines on the cow's body you can create the look of fur. Notice that the darkest areas of the cow are the nostrils, inside the ears, and under the belly.

The Badger

Wisconsin adopted the badger as its state animal on June 20, 1957. Earlier that year four schoolchildren found out that Wisconsin had never officially adopted the badger. They brought this matter to the attention of Wisconsin assemblyman Byron Wackett. He sponsored a bill that made the badger Wisconsin's official state animal.

Badgers are part of the Mustalidae family. This family includes skunks, weasels, and otters. Badgers are carnivores. They hunt small animals that live in holes in the ground. Badgers find their prey with their strong sense of smell. Then they use their long, sharp front claws to dig the animals out of their holes.

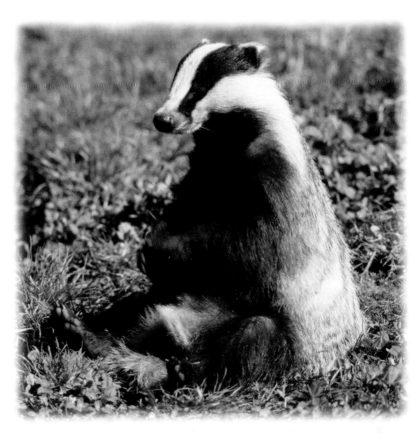

1

Look at the photograph before you start. You will draw the badger in a sitting position. First draw a triangle and then a half oval.

2

Add a triangle for the badger's head. Notice that the bottom point of the triangle points down to the tip of the half oval.

3

Use the guide shapes you drew to shape the head and the body of the badger.

4

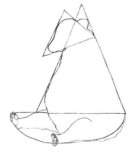

Now add the two hind legs of the badger.

5

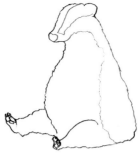

Draw the badger's back. Erase extra lines. Next draw the lines shown in the badger's head.

6

Add the badger's eye. Add the outline of the badger's arm.

7

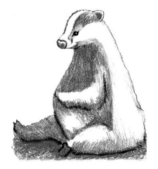

Shade your badger. To create the look of fur, use a lot of short lines. Notice the dark shadows under the badger's neck, inside its ear, under its arm, and on its chest.

Circus World Museum

Baraboo, Wisconsin, is the home of Circus World Museum. In the late 1800s, more than 100 circuses had their headquarters in Wisconsin. In 1884, five brothers founded the world-famous Ringling Brothers and Barnum & Baily Circus in Baraboo. In 1954, the Ringling brothers' lawyer chose Baraboo as the site for Circus World Museum. The museum opened in 1959. Its goal was to preserve circus history. Today visitors to the Circus World Museum can see exhibits about the Ringling brothers circus and other circuses. They can check out old-fashioned circus wagons and equipment. In the spring and summer, they can watch live circus acts. Circus World holds the Great Circus Parade in downtown Milwaukee.

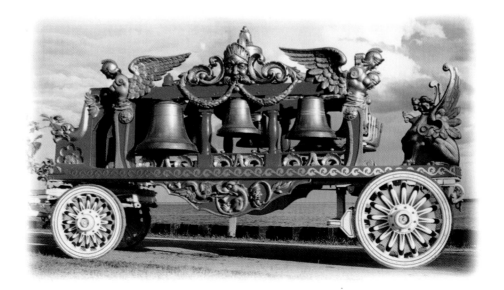

1

To draw the circus wagon, first begin with a rectangle for the cage. Underneath the cage, draw a long, thin rectangle. For the wheels, draw two circles. Draw the right wheel bigger than the left wheel.

2

Add circles inside the wheels. Add a curved line inside the cage.

3

Add six vertical lines inside the cage. Below the platform, add the back left wheel. Next draw a wide arch under the platform.

4

Draw the curvy line on top of the arch that you drew under the platform. After you do this, erase the arch.

5

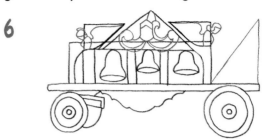

Draw three bells. Next add three triangular guides on top of the cage. These will be your guides as you draw the wagon decorations.

6

Draw a triangle on the right side of the platform. Look at the photograph of the circus wagon before you draw an angel to the left and the right sides of the wagon. In the middle, draw a man blowing wind.

7

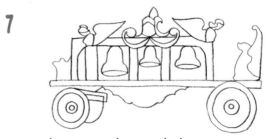

Erase the triangular guide lines on top of the wagon's cage. Next draw the winged creature on the right. Notice the way its wing curls up at the top. On the left side, draw the bench seat.

8

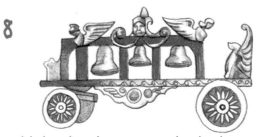

Add detail to the wagon wheels, the wind-blowing man, the angels, and the winged creature. Look carefully at the photograph to help you draw the details. Shade, and you're done.

27

Wisconsin's Capitol

Wisconsin's capital city, Madison, was named in honor of President James Madison. Wisconsin's government has a long history of social reform. Important decisions were made inside the capitol. On June 10, 1919, Wisconsin became one of the first states that allowed women to vote. In 1921, a law was passed to protect women from discrimination. In 1931, Wisconsin was the first state to pass an unemployment compensation act. This act meant that people who were unemployed could receive money from the state so they wouldn't starve or be left homeless. In 1945, the legislature passed a law to give money to people with disabilities. This money helped many get the care they needed to survive.

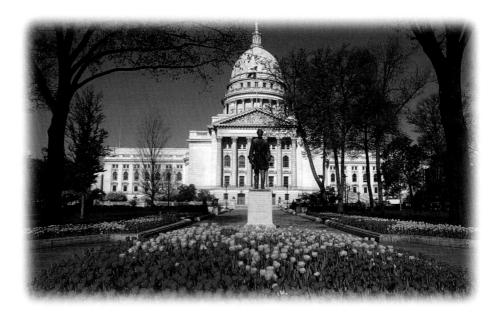

1

First draw a square. Now add two rectangles on either side of the square.

2

Add a thin rectangle on top of the square. Then add a triangle. Draw a rectangle on each side of the building.

3

Erase the line that crossed through the triangle. Now add the bottom five sections of the dome. Notice the way the top line of each section curves slightly.

4

Draw the dome. Then draw the small three sections on top of the dome using two rectangles and one tiny finger shape.

5

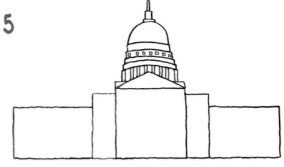

Add windows and columns to the dome.

6

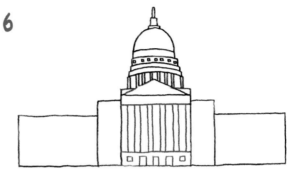

Add windows, doors, and columns to the center of the building.

7

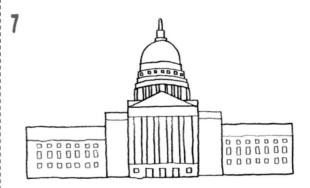

Add windows to each side of the building.

8

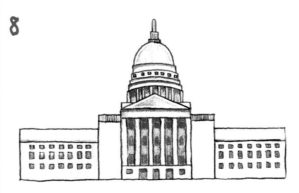

Shade the capitol, and you're finished!

29

Wisconsin State Facts

Statehood	May 29, 1848, 30th state
Area	65,499 square miles (169,642 sq km)
Population	5,224,000
Capital	Madison, population, 197,600
Most Populated City	Milwaukee, population, 617,000
Industries	Machinery, food processing, paper products, electric equipment, tourism
Agriculture	Cheese, dairy products, cattle, hogs
Nickname	The Badger State
Motto	Forward
Mineral	Galena
Soil	Antigo silt loam
Insect	Honeybee
Animal	Badger
Bird	Robin
Fish	Muskellunge
Flower	Wood violet
Tree	Sugar maple
Fossil	Trilobite (extinct marine animal)

Glossary

Arbor Day (AR-ber DAY) A special day that has been set aside to plant and to take care of trees.

carnivores (KAR-nih-vorz) Animals that eat the flesh of other animals.

centennial (sen-TEH-nee-ul) Having to do with the 100th anniversary.

chlorophyll (KLOR-uh-fil) A chemical substance that is found in plants and that turns their leaves green.

compensation (kom-pen-SAY-shun) To make up for something.

discrimination (dis-krim-ih-NAY-shun) To be treated badly or unfairly because of differences.

domesticated (doh-MES-tih-kayt-ed) To have tamed a wild animal for human use.

herbal supplements (ER-buhl SUH-pluh-mints) Substances made from plants and herbs that are taken to improve one's health.

legislature (LEH-jihs-lay-cher) A group of elected people that have the power to make the laws of a state or a country.

migrate (MY-grayt) To move from one area to another.

Mustalidae (mus-TAHL-ih-day) A family of animals that includes the weasel, the badger, and the skunk.

peninsula (peh-NIN-suh-luh) A piece of land that sticks out into water from a larger body of land.

preserve (pre-ZURV) To keep something from being lost.

prey (PRAY) Animals that are hunted and killed for food.

pulp (PUHLP) A mixture of ground up wood and moisture.

social reform (SOH-shul rih-FORM) Changes or improvements that help society.

Index

Web Sites

To find out more about Wisconsin, check out these Web sites:
www.50states.com/wisconsin.htm
www.wisconsin.gov/state/home
www.anythingwisconsin.com